PATCHWORK AND
QUILTING IN BRITAIN

Heather Audin

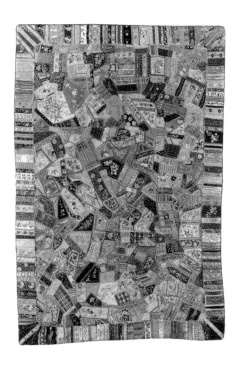

SHIRE PUBLICATIONS

Published in Great Britain in 2013 by Shire Publications Ltd, Midland House, West Way, Botley, Oxford OX2 0PH, United Kingdom.

43-01 21st Street, Suite 220B, Long Island City, NY 11101, USA.

E-mail: shire@shirebooks.co.uk www.shirebooks.co.uk

© 2013 Heather Audin.

A CIP catalogue record for this book is available from the British Library.

Shire Library no. 743. ISBN-13: 978 0 74781 241 8

Heather Audin has asserted her right under the Copyright, Designs and Patents Act, 1988, to be identified as the author of this book.

Designed by Myriam Bell Design, UK
Typeset in Perpetua and Gill Sans
Printed in China through Worldprint Ltd.

13 14 15 16 17 10 9 8 7 6 5 4 3 2 1

COVER IMAGE
A detail of the hearts and crosses coverlet on page 39.

TITLE PAGE IMAGE
Pawnbroker crazy coverlet, 1877, 116 x 175cm. Each piece has been heavily embroidered. It was bought from a pawnbrokers in London after the death of the original owner.

CONTENTS PAGE IMAGE
Diamond mosaic patchwork coverlet, c. 1840s–1860s, 224 x 267cm, accurately pieced from printed cottons. Made by Mary (Dennis) Cann or one of her daughters, who helped her run a draper's shop in Hartland after the death of her husband in 1842.

ACKNOWLEDGEMENTS
Thank you to The Quilters' Guild of the British Isles, Fiona Diaper, Bridget Long, Rosie Crook, Matt Thompson, Liz Whitehouse, Vivien Finch and Paul Audin for their help and support; Jeremy Philips, Catherine Candlin and Simon Warner for photography; the V&A and McCord Museum in Canada for images from their collection; Ruth Sheppard and Russell Butcher from Shire Publications and the authors of historical texts on the history of patchwork and quilting which are listed in the bibliography. This book is dedicated to all the members, past, present and future of The Quilters' Guild of the British Isles.

IMAGE ACKNOWLEDGEMENTS
I would also like to thank the people who have allowed me to use illustrations, which are acknowledged as follows:

Olive Gregson, page 56 (bottom); the McCord Museum, Montreal, Canada, page 16; The Quilters' Guild of the British Isles with David and Charles, pages 23 (top), 36 (top), 57 (bottom); the V&A Museum, pages 11, 17, 21 (bottom) and 22. All other photographs are from The Quilters' Guild of the British Isles collection.

Shire Publications is supporting the Woodland Trust, the UK's leading woodland conservation charity, by funding the dedication of trees.

CONTENTS

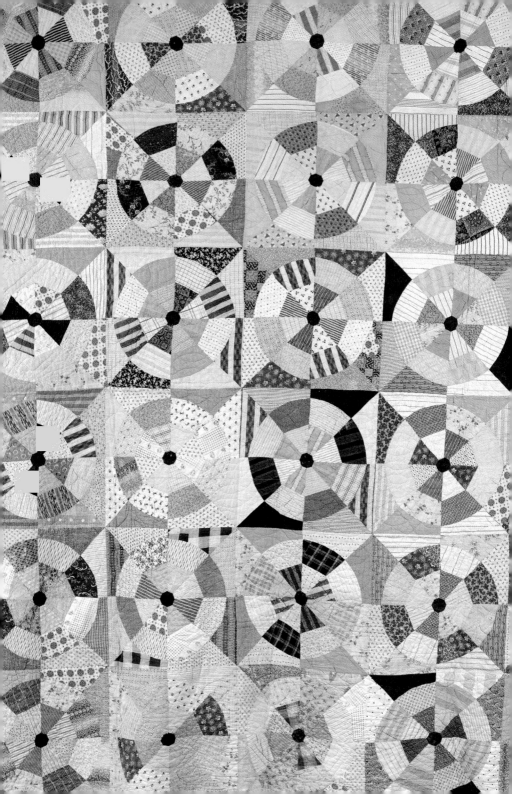

INTRODUCTION

THIS BOOK AIMS TO provide an illustrated guide to the history and development of patchwork and quilting in the British Isles from 1700 to the end of the twentieth century. It looks at techniques, styles, patterns and materials, using mainly examples from The Quilters' Guild collection of historic and contemporary textiles to show the developments and changes in these crafts over the past three centuries. It is hoped that this will provide a useful visual tool and a starting point for further research into specific areas of interest in the history of patchwork and quilting.

The terms 'patchwork' and 'quilting' are often used together and have almost become synonymous with each other. However, they are two separate crafts, which have a linked but also distinct history of development.

A quilt consists of three layers: a top layer (which can be plain or pieced); a central warmth-giving layer (cotton, wool or blanket); and a backing. These three layers are joined together by stitches, which can be a collection of decorative motifs (flowers, leaves, feathers, hearts), a simple repetitive design (square diamonds or zigzags) or at its simplest, evenly spaced knots that join the three layers together and tie on the top of the quilt. The stitches that join the layers together are quilting. Two layers – a top and a backing without central wadding – make the item a coverlet. Coverlets can still have quilting stitches to join the two layers together. A single layer is called a top. As there is no other layer to join to, a top will not be quilted, and is therefore just made from patchwork or appliqué.

Patchwork refers to a new piece of cloth that is formed by joining different and contrasting pieces of fabric together. This can be done using a variety of fabrics, by hand or machine sewing, and in a variety of methods and designs. There are numerous different patchwork designs and

Opposite: Wheels patchwork quilt, late nineteenth century, 222 x 255cm. Made from roller-printed dress cottons in a wheels shape patchwork design.

North Country yellow and white quilt, c. 1910, by quilt teacher Nellie Ellison, 226 x 241cm. The traditional quilt motifs of plaits, feathers and freehand scrolls have been drawn on with blue pencil, which is still visible.

This house block quilt, 1978–9, 188 × 236cm, was the first piece in The Quilters' Guild collection. It was made by twenty members of the Quilt Circle who were instrumental in the formation of the Guild.

methods of construction. A frame design starts with a central shape which is surrounded by frames or borders of plain or pieced fabric strips. A block design such as 'log cabin' consists of individually created square blocks of strips, which are joined together and arranged to form the overall design. Other block patterns, such as baskets and stars, use joined pieces to create each block; these are then sewn to each other to form repeating designs. Crazy patchwork is a random arrangement of different shapes applied to a foundation fabric and is often embellished to cover the seams. Mosaic patchwork is made by wrapping fabric around a paper template, tacking/basting down and oversewing/whipstitching the shapes together by hand. It is commonly made using geometric shapes, such as hexagons, octagons and diamonds.

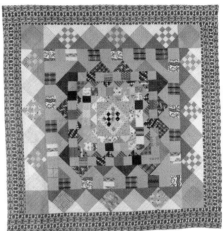

Scott log cabin coverlet, c. 1860, 179 x 182cm. The log cabin block has light and dark strips of fabric arranged around a central square. The arrangement of the individual square blocks can give a different overall effect.

Roller-printed cottons frame quilt, c. 1850–1900, 210 x 213cm. Frame patchwork starts with a central square or rectangle, and strips are added on all four sides to form borders or frames, which may be plain or pieced.

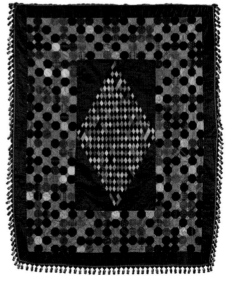

North Country strippy quilt (see page 45), c. 1920s, 216 x 243cm. Wholecloth quilts use the patterns created by quilting rather than patchwork pieced designs to create the decorative surface.

Octagon and diamond mosaic table cover, c. 1890–1910, 136 x 170cm. Mosaic patchwork has fabric folded around paper templates, which is then oversewn or whipstitched together by hand.

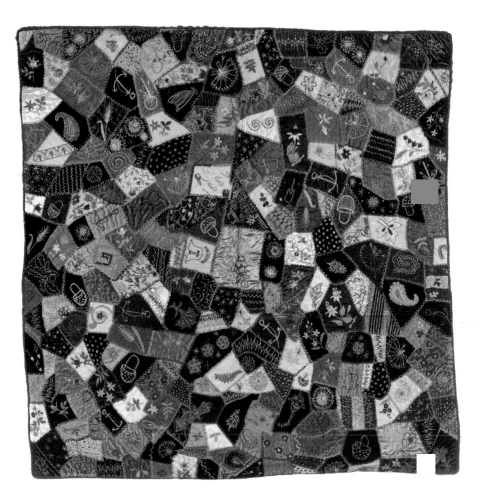

Crazy patchwork coverlet, 1886, 82.5 x 82.5cm. Crazy patchwork uses random shapes of fabric sewn to a foundation backing. Seams and raw edges are covered with decorative embroidery stitches, and embellishment can also be used within the pieces.

Appliqué can also be used with or instead of patchwork to provide a decorative design. Shapes are cut out and applied to the surface of a foundation cloth, with the raw edges turned under or covered by embroidery stitches.

Where a combination of patchwork and quilting is found together, the quilting designs can follow the shapes already provided by the patchwork or ignore them completely to form a new, unrelated design. In contrast, a wholecloth quilt, where large pieces of plain cloth form the top and bottom layers, uses the design and layout of the quilting motifs alone to produce the decorative textured surface.

It is often assumed that patchwork is a product of necessity and thrift, responding to the need to create a new piece of cloth and a practical object

from any leftover scraps, or recycled from worn clothing and household furnishings that no longer serve their original purpose. Whilst this may have been true for some patchwork made by those lower down the social scale, patchwork was, at times, also created by ladies who had the leisure time and instruction to produce highly decorative pieces from fashionable fabrics. Makers would buy new fabrics especially for the purpose of patchwork, as well as incorporating their treasured scraps.

The fabrics used in patchwork often provide the most useful dating evidence when it comes to a piece with no provenance, although an element of caution is always required. As happens today, a sewer's fabric 'stash' could span several decades, and even incorporate any favourite, expensive or sentimentally treasured fabrics inherited from a previous generation, resulting in a quilt or coverlet with fabrics easily spanning half a century. The finished piece is therefore only as old as the newest fabric.

In the case of mosaic patchwork containing paper templates, handwritten or stamped dates on re-used letters, accounts and envelopes are often cited as evidence of the date of the patchwork piece. Again, the paper could have been collected over a period of time, and was in itself an expensive

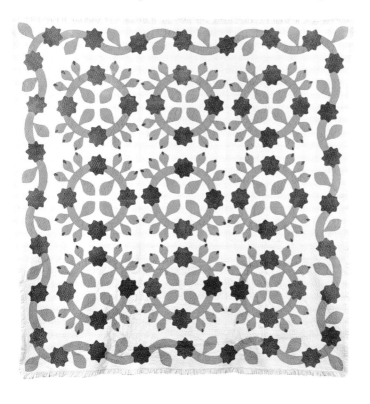

North Country appliqué quilt, c. 1880–90, 230 x 233cm. The flowers and leaves have been cut out from red and green cotton and applied to the white cotton quilt surface. The edges are folded under and slipstitched to prevent fraying.

This star patchwork coverlet, c. 1870, 206 x 245cm, is an example of cotton pieced patchwork in The Quilters' Guild collection from the nineteenth century. The shapes have been made by mosaic patchwork, which has been surrounded by two frames.

commodity, hence the need for recycling. It is likely there would have been some delay between the creation of the paper document and its use in patchwork, making the finished product at least the date of the paper if not some years after.

The early history of patchwork and quilting in Britain is difficult to pinpoint with accuracy and changing definitions and inconsistent terminology can make written documents unreliable. References to quilts can be found in the inventories and wills of the wealthier classes from the thirteenth century. Their high value made them treasured possessions in the household, often worth more than the bed itself. They could be made from silk or linen, and were often professionally made, with quilted backgrounds adorned with embroidered decoration. The fourteenth-century romance of *Arthur of Lytel Brytayne* is the first British literature source to refer to a quilt, although a French poem in the twelfth century, 'La Lai de Desire' mentions a richly made silk quilt on a bridal bed. By nature of their age, surviving examples from these first centuries of known quilting in Europe are very rare. One example, the Sicilian Tristan

quilt, survives in the V&A collection, with a sister quilt, the Coperta Guicciardini, in the National Museum of the Bargello, Florence. Thought to have been originally part of the same piece and later divided, these quilts date from 1360 to 1400 and depict scenes from the medieval legend of Tristan, with padded figures outlined with brown and white linen thread.

Quilts remained popular and evident in sixteenth-century inventories, and it is presumed they were still the preserve of wealthier society (as we have no written or surviving evidence from lower down the social scale). The formation of the East India Company in the early seventeenth century led to imports of expensive Indian textiles and quilts which became very desirable for their exotic and colourful designs. In clothing, previous centuries had seen quilting used in armour, and by the seventeenth century it was also used for fashionable garments, such as jackets, waistcoats, day and night caps and hats for men, women and children. A surviving ivory silk quilted doublet and breeches from *c.* 1635–46 exists in the V&A collection, showing its use in a wealthy courtier's dress. The construction and seams suggest the quilted fabric was originally a bed cover remade into a fashionable outfit and decorated with braid and ribbons.

References to patchwork before the eighteenth century are more difficult to find than references to quilts. Paned work, the ancestor of patchwork, was used in bedding from the early sixteenth century, where fabric lengths would be joined together to provide a contrast of colour or fabric. In her research for the V&A quilts exhibition in 2010, Clare Browne found the earliest inventory reference to patchwork in Britain so far to be 1695. In Europe, inlaid patchwork was known from the sixteenth century. This distinct style of textile uses woollen cloth, which is sewn edge to edge without seam allowance, and was used to produce pictorial pieces depicting stories or scenes. The remaining physical evidence for patchwork before the eighteenth century is slim. However, the use of the term 'patchwork' in early eighteenth-century literature shows that it must have been in common use, as writers would not have used a term unfamiliar to their readers. Apart from inlaid patchwork, Britain appears to have the earliest European patchwork tradition. Trade, travel and emigration subsequently allowed the transference of techniques and styles to British colonies such as America, Canada

Ivory silk quilted doublet and breeches, *c.* 1635–40, from the V&A collection. Quilting was fashionable in seventeenth-century clothing and this outfit has been made from a pre-existing quilt.

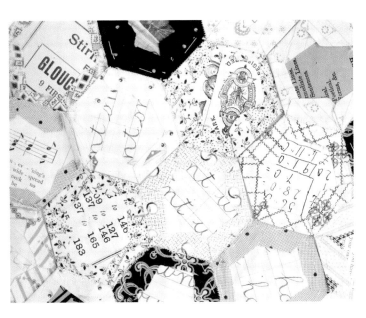

Mosaic patchwork uses paper templates. The paper was often recycled from books and documents. The templates used in this example have handwritten and printed text, including handwriting practice, accounts and printed advertisements.

and Australia. Different countries later developed their own style away from British influence.

Whilst this book aims to provide an overview of patchwork and quilting over the last three centuries, the lengthy time span dictates that not every detail can be covered in the space available. It is hoped that the reading list provided will be useful in exploring specific topics in more detail. In many cases, each area of patchwork and quilting is a book in itself.

In looking at the history of patchwork and quilting there are, as always, pitfalls and red herrings – those items whose style and fabrics do not seem to fit the provenance; there are also completely unique pieces that are difficult to place. The production of patchwork and quilting is always subject to personal taste and whilst styles may be similar, pieces will not always look identical. There are always exceptions to the rule and allowances should be made for individual circumstances and flair. We also must be cautious in assuming that surviving historic examples are typical or representative. For those items that do survive, they could have been particularly treasured, made of expensive fabrics or even considered unfashionable and therefore never used. This gives them a good rate of survival but they are not necessarily representative of what was popular at the time. It is also likely that older surviving pieces from the eighteenth century were made by the upper classes; by contrast, the practical pieces created for working-class families were made to be used, and would have been used to destruction.

Opposite: Cotton patchwork quilt, c. 1960s–70s, 178 x 220cm, made by Ray Marshall. The twentieth century was one of decline and revival for patchwork and quilting, and by the late 1970s, popularity was once again beginning to grow.

'PATCHWORK IS THE FASHION OF THIS AGE': 1700–1800

THE EIGHTEENTH CENTURY saw two main developments in the craft. The silks used in patchwork at the start of the century gave way to new and fashionable cotton fabrics, which became popular and were widely used for both dress and furnishings. The square block template, often halved and quartered into triangles, was a key characteristic of the early eighteenth century, whilst the hexagon and corresponding tessellating mosaic patchwork shapes appeared by the closing decades of the eighteenth century. Quilting was a popular and decorative embellishment not only on bed covers but also on clothing, and developments in fashionable dress gave rise to the era of the decorative and visible quilted petticoat – a major feature of female informal dress.

Patchwork was well known as a fashionable pursuit for ladies of the gentry and upper middle classes in the eighteenth century, and is mentioned in popular literature including the 1706 play *Hampstead Heath* by Thomas Baker ('Patchwork is the Fashion of this Age') and *Gulliver's Travels* by Jonathan Swift, written in 1726. Gulliver's clothes, fitted by three hundred Lilliputian tailors, 'looked like the patchwork made by the ladies of England'. The earliest patchwork in The Quilters' Guild collection is a 1718 silk patchwork coverlet. It is the earliest known dated British patchwork in existence, and is completely made of silks apart from six pieces of wool velvet. Many of the fabrics show signs of previous use, such as unpicked seam lines or general wear; in some cases, small patches have been pieced together from tiny scraps. The range of silk fabrics represents nearly a century's worth of collecting, showing how valuable and treasured these fabrics were. The back is made from random patches of linen and the same initials, 'EH', in blue silk cross stitch can be found on two different pieces of linen. The coverlet came from the Brown family, who are known to have a farming ancestry in Aldbourne, Wiltshire, but so far the exact maker (and the identity of 'EH') remains elusive, despite an in-depth investigation into the Brown family tree.

The large range of domestic and rural animals, including cats, dogs, birds, rabbits, pheasants and partridge, support the theory of a rural origin, and it

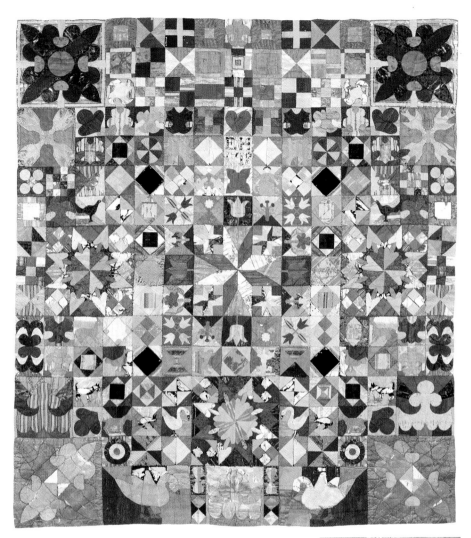

Above: Silk patchwork coverlet from 1718, 169 x 185cm, constructed from 182 blocks of geometric, floral and figurative motifs all pieced over paper templates. X-ray examination of the templates revealed a numbering system, used to keep track of the complex design.

Right: Detail of the 1718 silk patchwork coverlet showing the initials 'EH' and the date '1718' in disintegrated black silk. A male and female figure, tulips and heart motifs can also be seen.

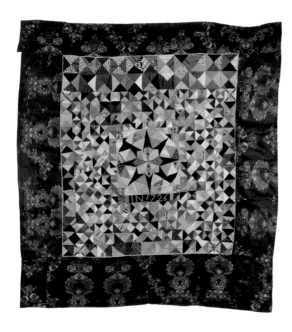

This silk, velvet, cotton and linen patchwork coverlet, 208 x 208cm, made in 1726 in Norwich, bears design similarities to the 1718 coverlet. It is now in the collection of the McCord Museum in Montreal, Canada.

is thought that the inclusion of a heraldic Lion and Unicorn relates to its historical context, perhaps indicating royal support for George I after the failed Jacobite rebellion of 1715. Good-quality silks were used (although not the best available), indicating that the maker's family were of good social position. This is further supported by the leisure time needed to work on the project, the use of expensive paper for the templates and the competent sewing skills, demonstrated by the accurate piecing and the neat stitching: 15–20 stitches per inch.

Other rare surviving examples from the eighteenth century show some similarities in designs and use of silk fabrics. A coverlet with the date 1726, now in the collection of the McCord Museum of Canadian History in Montreal, Canada, uses the same quartered square triangle geometric blocks that feature in the 1718 coverlet. The blocks also have been pieced over paper templates, which remain intact, and the central pieced section is lined with striped silk. An outer border of a single layer of silk was probably recycled from a dress and added at a later date. Like the 1718 coverlet, the fabrics are from a wide date range, representing nearly a century of fabric collecting. The coverlet was taken to Canada when the owner's family emigrated from Norwich in 1832. Several examples in the V&A's collection are dated from the early to mid-eighteenth century and are made from silks that have been collected over a number of decades, and some also feature triangular patchwork made from the square block.

It is unusual for cotton patchwork or quilts made before the last decades of the eighteenth century to survive. Rare examples include a patchwork quilt and curtain made from printed cottons at Levens Hall, Cumbria, thought to date from the early eighteenth century, and a set of clamshell patchwork bed hangings dating from the early to mid-eighteenth century in the V&A collections. Cotton was very highly prized, and the high-quality painted and printed Indian cottons with their exotic multi-coloured chintz designs were unparalleled in Europe, making them a desirable commodity for fashionable garments and bed covers. The term 'chintz' referred to the

large-scale floral motifs found on imported Indian painted cottons, which had a full range of colours. Their import and increasing popularity was seen as detrimental to the home textile industries of linen and wool, and as a result, the import of Indian printed cottons was banned by an Act of Parliament in 1700. However, the entry of these forbidden fabrics into the country for immediate re-export was still permitted, resulting in a large quantity of these highly desirable textiles 'going missing', to be sold illegally. In an attempt to control the exploitation of this loophole, a further Act of 1720 banned 'the Use and Wear of all printed, painted, stained or dyed Callicoes,

Silk and cotton patchwork quilt, *c.* 1760, made by Mary Parker for her wedding in 1770. The design based around the square block has similarities to the 1718 coverlet; the silk ribbons are *c.* 1720s–40s.

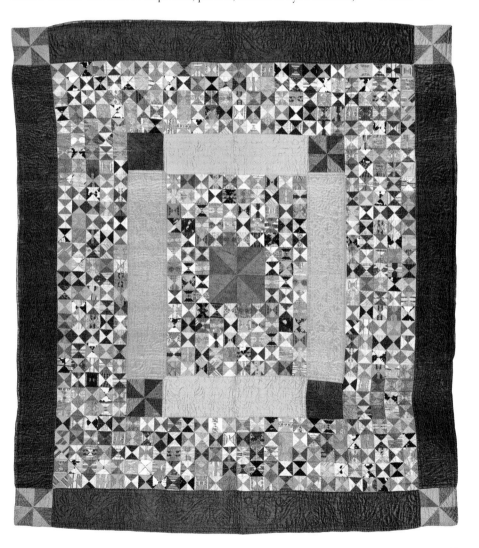

in Apparel, Houshold-Stuff, Furniture, or otherwise' from 25 December 1722, which included both Indian and British-made cotton. This only served to increase its desirability; wearers would buy Indian cottons on the black market but claim their fashionable fabrics had been purchased before the restrictions were imposed. In the face of the competition, British home textile industries began to develop and improve their own printing manufacture, and managed to get round the restrictions by producing fustian, a cloth with a linen warp and a cotton weft. The import restrictions were repealed in 1774, when a new act required the developing British cotton industry to weave three blue threads into the selvedge of the new British all-cotton cloth as identification for tax purposes. These selvedges can be particularly useful in dating if patchwork pieces have been used right to the edges, placing fabrics between 1774 and 1811 when the Act was finally repealed.

Copper-plate printed fabric showing the delicate and crisp design that could be produced by fine plate engraving. Plate prints were often monochrome designs.

Quilts, coverlets and tops from the later decades of the eighteenth century demonstrate the fashionable status of printed cottons, and often contain a wealth of different printed designs and colours that were increasingly available. British cotton production and printing developed rapidly and many designs were influenced by the popularity of Indian chintz. Patterns were printed using hand-carved wooden blocks and the large-scale designs would be repeated with the aid of a register mark; this was a small pin in the corner of the block which could be matched up to enable a flowing repeated design. As each colour required a separate block and a different dye process, the production of large-scale printed fabrics was time-consuming and therefore expensive. Simpler and smaller-scale designs were also available, and required less time, making them more affordable. Extra details could be added by 'pencilling', which meant they were hand painted onto the cotton after the main design had been printed. This was done with indigo blue dye, which oxidised quickly and had to be applied to the fabric with haste, resulting in varying degrees of accuracy. Plate printing was also used, and metal plates, which required more time and skill to produce, could be engraved with finer detail than wooden blocks, producing delicate, crisp designs that were naturally more expensive. Many furnishing and early dress fabrics were put through a process of calendering, to help repel dirt

and therefore reduce the need for washing. Fabrics were passed through pressurized rollers, which gave them a glazed and shiny surface, sometimes still evident on the fabrics used in surviving quilts and coverlets.

The quilts and coverlets made from late eighteenth-century fabrics in the Guild's collection often include evidence of both furnishing and dress fabrics. One simple frame quilt (see below) has large pieces of furnishing fabrics on both light and dark grounds which feature popular floral designs and repeated rows of a bird with nest in the central stripes, and dates from the last decades of the eighteenth century. This quilt was made in England but then taken to Australia when the family emigrated. Many items from this period are just coverlets or single patchwork tops, but this piece contains patchwork and quilting. The quilt design is arranged in frames with a central medallion containing a mixture of floral motifs. Unlike later nineteenth and early twentieth-century quilts, the quilting motifs and layout are not standardised, but are individual to the maker.

Another popular style in the late eighteenth century was the Broderie Perse coverlet (which means 'Persian embroidery'). Using the large-scale

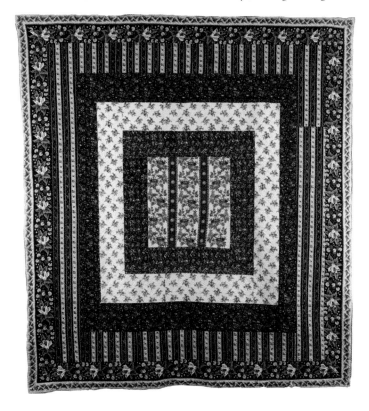

Late eighteenth-century frame quilt, 215 x 290cm, made from large pieces of block-printed furnishing fabrics on light and dark grounds. The central three rows have an interesting bird and nest repeated pattern (detail below).

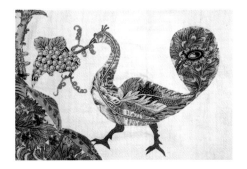

floral and exotic bird prints popular in Indian chintz, whole motifs were cut out and then rearranged to form a new design and applied onto a plain calico background and the raw edges turned under or covered with a decorative stitch. The 'Tree of Life' design became popular in Europe after its introduction through the import of Indian textiles. Characterised by a central tree with flowers and animals, it represents immortality, protection and healing in many cultures, and was considered to be the representation of everything foreign and exotic.

Not all pieces feature patchwork and quilting together. Although some quilting was done at home, high-quality quilted items such as petticoats, clothing and bedcovers were produced by professional seamstresses and needlewomen in small workshops or in their homes, and then sold through commercial outlets. A white linen wholecloth

Above: Two details of the 'Tree of Life' Broderie Perse coverlet, 305 × 305cm, showing the floral tree design and a peacock, whose body and feathers have been pieced together from different printed cottons. On loan to The Quilters' Guild collection.

Right: Early eighteenth-century linen cot quilt, 115 × 101cm, with pictorial quilted motifs in the arches and central medallion including a castle, a ship, a mermaid, a merman and various animals.

cot quilt in the Guild's collection, thought to date from *c.* 1700–10, was possibly made in a professional workshop. It is densely quilted in backstitch with a central medallion and a border of arches; the central medallion features a lady and the border of sixteen arches contains motifs including a mermaid, a merman, a sailing ship, a castle, a lion, a camel and other animals. The motifs are almost identical to a cot quilt in the V&A collection, which is decorated with a large amount of floral embroidery and has a quilted date of 1703, suggesting the motifs were copied, possibly from a pattern book. Other small fragments of eighteenth-century quilting are present in the collection, and have probably been cut down from larger bed covers.

Detail from an eighteenth-century baby's corded quilted cap with pulled work and French knot embroidery.

Quilted clothing was fashionable in the eighteenth century, decorating women's petticoats, men's and women's waistcoats, babies' caps, pockets and stomachers. Both flat quilting (sewn through two or three layers, with running or backstitch in the eighteenth century) and corded quilting (where parallel channels are sewn and cord inserted from the reverse to provide the textured relief) were popular, with embroidery stitches such as pulled work and French knots often accompanying the latter on items such as babies' caps and decorative waistcoats.

By the mid-eighteenth century it had become fashionable for women's robes to be open at the front, with the front of the outer skirt being set back to reveal the petticoat underneath. Quilted petticoats had been worn in the seventeenth century for warmth and comfort, but this change in fashion encouraged more intricate and decorative designs, which could be interchangeable and worn with different dresses of the same or contrasting colours. The outer fabric could be made from linen, satin or silk, whilst the backing was often a more hardwearing and practical fabric such as coarse linen, calico or glazed wool. The central wool wadding did not extend all the way to the waist, allowing the thinner layers of top and backing fabric to be pleated at the waistband without creating too much bulk around the waistline. The waistband often tied at each side with a long gap in each side seam to allow access to the pocket or pair of pockets worn on a waist tape underneath. Petticoats were often remodelled and resized to fit a different wearer, so the surviving waistband and pleat arrangement may not always be original.

Pair of yellow silk quilted pockets, *c.* 1745, in the V&A's collection, with scroll and square diamond motifs. Pockets were separate accessories; they were tied around the waist and were accessed through openings in the dress and petticoat side seams.

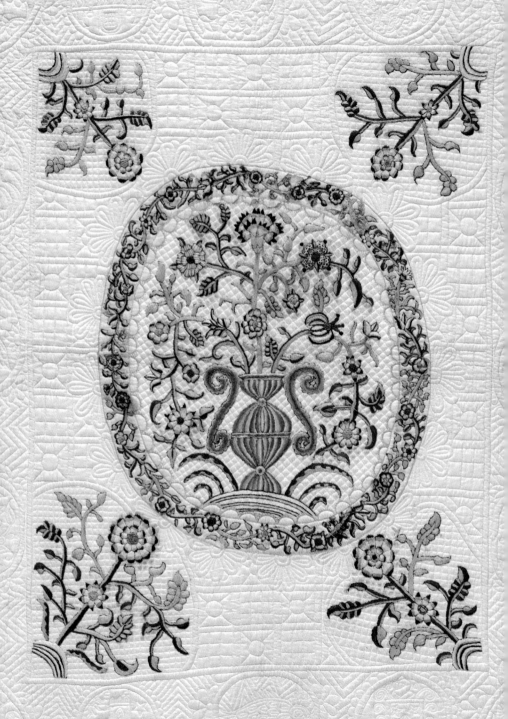

Quilted petticoats could be ordered from a professional quilter, purchased off the peg or purchased in the form of quilted material or fabrics with marked designs to be made up at home. Earlier petticoats had a more decorative front panel where the garment would be most seen, but plainer quilting elsewhere. With the popularity of the polonaise fashion in the third quarter of the eighteenth century, skirts were gathered up at the back with internal ties or external buttons and loops, meaning the full circumference of the petticoat's exposed hemline needed to be decoratively quilted. By the end of the century, the changes in fashion towards a slimmer silhouette meant there was no place for the wide hemline and bulky shape of the quilted petticoat. However, the simpler quilted petticoats used by lower-class women, made at home from stronger fabrics as a practical, warmth-giving item of clothing, continued to be worn well after it was considered fashionable by higher society. Quilted skirts, worn as outerwear, remained a practical element of workwear in rural communities and amongst certain occupations (such as fisherwomen) throughout the nineteenth century. Their use in everyday workwear means their survival is less common than their grander eighteenth-century counterparts.

Mid-eighteenth-century silk quilted petticoat with a linen lining and wool wadding. The hemline has a more decorative floral design than the plainer waved lines near the top where the quilting would be less visible.

Opposite: embroidered linen cot coverlet dated 1703 from the V&A's collection, which features very similar quilted designs to the cot coverlet in The Quilters' Guild collection shown on page 20.

Left: Corded quilted design on a linen petticoat, which has a hemline border of floral motifs and a scalloped wave design up to hip level. It is pleated into a linen tape waistband and has pocket openings at both sides.

23

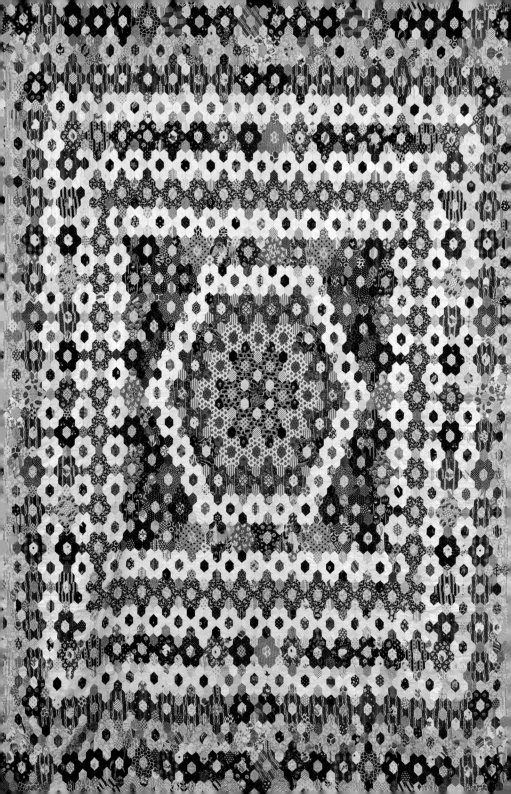

PRETTY PRINTS AND COLOURFUL COTTONS: 1800–50

THE NINETEENTH CENTURY saw great changes in popular styles and fashionable fabrics, influenced by developments in technology and manufacturing, dyeing techniques and printing processes, all of which were reflected in patchwork and quilting as the century progressed. At the start of the century, high-quality cottons – with finely printed designs made using complex dye processes in several stages – were the high-society fabric of choice. As designs were simplified and colour palettes reduced, cottons moved down the social scale. By the mid to late century, silks and velvets vibrantly coloured with new, synthetic dyes, became the fashionable alternative.

The printed cotton patchworks of the early nineteenth century demonstrate the huge variety of different colours and designs that was available. Roller printing, where smaller designs were engraved on a copper roller to allow a continuous repeat, had been patented in 1783 by Thomas Bell, but due to technical issues did not take over as the main method of production for printed dress fabrics until the nineteenth century. Rollers were initially hand engraved until mechanised production was developed in the 1820s. Once roller printing gained favour in producing the smaller-scale designs fashionable for dress prints, block printing was used only for the larger-scale designs in conjunction with roller printing on furnishing textiles.

Printing fabrics with colourful designs was a complicated process: the more colours a design had, the longer it took to manufacture, as each colour had to be applied in a separate layer. The range and varying shades of colour produced were a testament to the ever-increasing skills of the manufacturers, who would overlay different colours and use a range of processes to achieve vibrant, shaded and interesting printed patterns. Until the invention of synthetic dyes, natural dyes were the source of colour, and required the use of a mordant on cotton and linen fibres. The mordant acted as a fixative that allowed the dyes to bond to the fabric, making them more colourfast to water and light. Mordants included solutions of iron, aluminium, copper, chrome and tin, and would be printed on the fabric, which would then be submerged in the appropriate dye to produce the desired colour.

Opposite:
The Mary Prince coverlet,
c. 1803–15,
230 x 275cm.
A linen tape around the edge has the embroidered date 1803, although the fabrics in the centre are newer than this, leading to speculation that it was repaired later.

Madder, a plant dye, was used to give a range of different colours according to the mordant used – reds from alum, purples from iron and browns from a mixture of both. In 1868, a synthetic version of the dye agent in madder called 'Alizarin' was produced, and by the 1870s this was more widely used than the natural plant extract. The iron mordant used in purple cottons does present problems with age. Over time, it can oxidise, turning the purple colour to brown in patches or across the whole of the fabric. Indigo was the main blue dye used throughout the nineteenth century, but it was difficult to use as it had to be applied quickly before oxidisation in the air. Indigo blue on printed cotton was usually produced by resist dyeing – where a solution of flour, clay, gum and copper sulphate was printed on the fabric and the cloth submerged in the indigo dye, which took to the areas not covered by the resisting substance. Prussian Blue was also available, which was more green/blue than indigo and was widely used even though it was not so colourfast. Yellow was made by plants and barks such as quercitron, Persian berries and fustic, which were combined with alum to produce a clear yellow, iron for an olive green and chrome for a more orange shade. Green was difficult to produce and was often made by printing yellow over blue, but the yellow faded quickly leaving blue-dominated foliage in many floral print designs. Copper green, made with verdigris, was popular in the 1820s and 1830s, but was not colourfast and was no longer used by the mid-nineteenth century. Green was not a reliable fast single colour until the artificial production of an 'Alizarin' green in 1895.

Many of the quilts, coverlets and tops in The Quilters' Guild collection surviving from the first years of the 1800s are made from a mixture of dress and furnishing cottons that span several decades and include cottons from the last decades of the eighteenth century. Many of them are mosaic patchwork, which allows for greater accuracy. The large variety of fashionable cotton fabrics, the use of paper templates and the complicated designs point to a level of education, money and time from women in higher society. Both the Mary Prince coverlet and the Mrs Billings coverlet are meticulously pieced from a beautiful array of different printed cottons. The range of colours and fabric designs is astonishing, including interesting animal spot motifs and very contemporary-looking geometric designs. The Mary Prince coverlet, which has an embroidered date of 1803, has several hexagons whose selvedge contains the three blue threads required of British-made cotton between 1774 and 1811. Interestingly it also contains a fabric using the lapis dyeing technique (a process where madder red could be printed directly next to indigo blue without leaving a gap) which was not developed until after the supposed completion date, showing that even quilts with dates cannot be taken at face value. The Mrs Billings coverlet (opposite) is a complex piece consisting of multiple frames of intricately pieced mosaic patchwork, and the fabrics date

from the 1780s to the 1810s. Both pieces are just patchwork tops, which were unbacked and unquilted, intended only as decorative bed covers. Most of the papers have been removed from these pieces, but a few remain on the outer borders of the Billings coverlet. Paper templates would have been made from anything that was no longer useful. There is a romantic notion often associated with a quilt's story that the papers are always love letters that have been sewn into the quilt to be kept close to the heart. Whilst this may be true, perhaps more frequently used (and less romantic) documents include old letters, envelopes, accounts, shopping lists, handwriting practice and printed works such as pamphlets or school books. The fabrics themselves could be saved up over time, and patchwork often contains fabrics that span a decade or more.

The Mrs Billings coverlet, c. 1805–10, 215 × 215cm, consisting of multiple frames of paper-pieced cotton triangles, squares and hexagons, and thought to have been made in West Yorkshire. The oldest fabric dates to the 1780s.

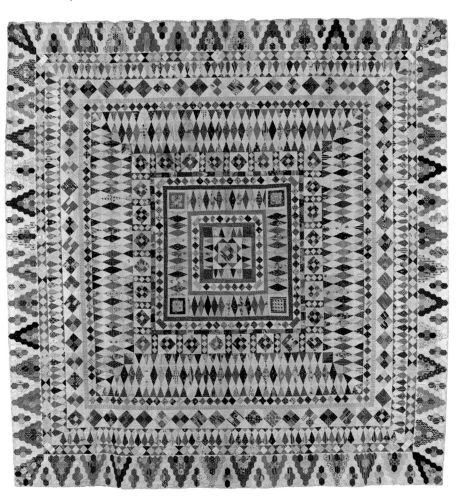

27

However, it was also possible to purchase off-cuts and ready-cut pieces from a draper or haberdashery store specifically for use in patchwork. In 1811, Jane Austen wrote to her sister Cassandra, asking, 'Have you remembered to collect peices [sic] for the patchwork? We are now at a standstill.'

More utilitarian frame-style quilts are found throughout the century, as are appliqué quilts and coverlets, although these are far less common. The Challans appliqué coverlet is dated 1811 and it is interesting to compare it with the pristinely stitched mosaic patchwork from the same era. The triangle and zigzag pieces have no uniform size and where the fabric has disintegrated, the remaining large running stitches are in sharp

This squares patchwork quilt, 228 x 253cm, was made by Mary Robson in 1801. It is hand quilted with a circular medallion of floral motifs, square diamond infill and a border of zigzags with various motifs.

The Challans appliqué coverlet, 1811, 215 x 230cm. It is simpler in design than the mosaic patchwork from the same period. The indigo blue fabrics were unfashionable at this time, and this, along with the coarser stitches, points to a lower-class maker.

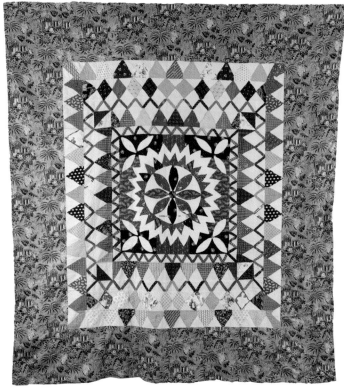

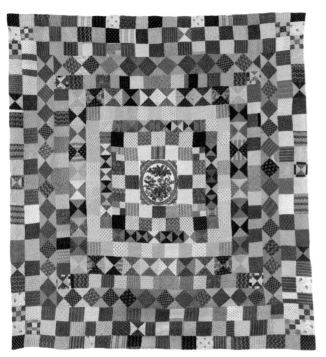

Above: Single block-printed cotton panel, c. 1820, sold individually or in lengths for use in patchwork and domestic projects. The same design features in the centre of the Sidmouth frame quilt.

Left: The Sidmouth frame quilt, c. 1820–40, 234 x 255cm, has an elaborate quilting layout and a central block-printed panel, popular for use in home furnishings in the first decades of the nineteenth century.

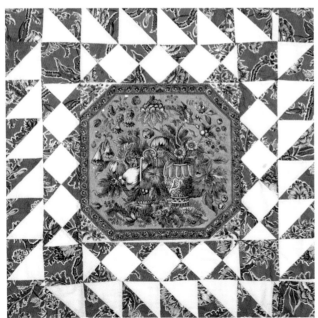

Patchwork fragment, 78 x 78cm, with an octagonal framed central block-printed panel featuring a vase of flowers and basket of fruit on a tea-coloured ground.

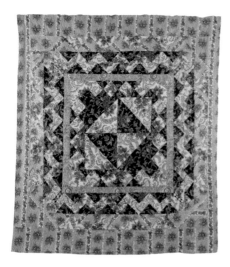

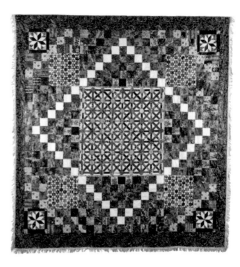

Frame coverlet, c. 1830s, 249 x 283cm, made from floral glazed furnishing fabrics. It is thought to have been made by Esther Cooper Cockram Perry, near Stafford.

Furnishing cottons coverlet, c. 1820–40, 260 x 271cm, with complex mosaic piecing in the centre and corner squares. The highly glazed surface is still visible and the excellent condition suggests it was hardly used.

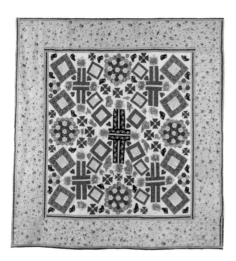

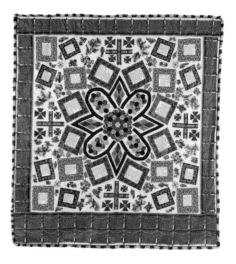

The William Wyatt coverlet, 1849, 254 x 267cm, an unusual design with appliqué motifs and embroidered religious texts. The maker, Anne Wyatt, was related to the maker of the Bloomfield coverlet, explaining the similar design and shared fabric in both pieces.

The Edwin and Mary Bloomfield coverlet, 1850, 230 x 246cm. It is thought that this and the Wyatt coverlet were commemorative pieces; the text relates to the death of children, which was experienced by both families.

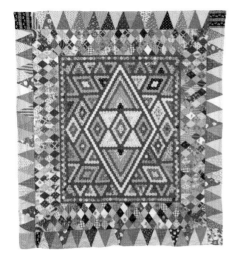 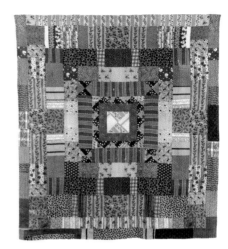

contrast to the neat oversewing on the mosaic patchwork pieces. The poorer quality of fabric is also noticeable, and the indigo printed cotton used in the central medallion was by that time so unfashionable that it was often sold under the counter to ensure that the right class of clientele was not offended.

Block-printed panels were popular throughout the first quarter of the nineteenth century. Often featuring baskets of flowers, fruits or birds, these panels were especially printed and sold for use in domestic projects, and were the ideal size for chair covers, cushions or as feature blocks in quilts and coverlets. Panels commemorating famous battles or royal activities were also popular, and commemorative designs were made to celebrate the Golden Jubilee of King George III, the marriage of Princess Charlotte to Prince Leopold of Saxe-Coburg in 1816, and Wellington's victory at the Battle of Vitoria, 1813 and Waterloo, 1815. The use of a central block-printed panel is present in several items within the collection. The Sidmouth quilt has a central block-printed panel of a bird feeding its young, which is identical to an unused block-printed panel in the collection. The Thorne quilt features block-printed panels in the corners of the frames as well as a cluster of four at the centre, showing they were used throughout the quilt as well as a central attraction.

Above, left: Mosaic pieced coverlet, c. 1860s, 278 x 253cm, made from printed cotton hexagons arranged to form diamond designs in the centre, with borders of triangles and squares on point.

Top right: Frame quilt, c. 1840–70, 218 x 233cm, made from strippy and floral printed fabrics dominated by purple, a very popular colour from the mid-century. It is simply quilted with a cable motif in a strippy layout.

Right: Printed cottons patchwork pocket, c. 1840s, with two main compartments and a third horizontal opening with triangular flap. Pockets were less fashionable by the mid-nineteenth century, though still used by older generations and in rural communities.

THE FASHION
FOR FANCYWORK:
1850–1900

THE INVENTION of the sewing machine in the mid-nineteenth century had a major impact on sewing at home. The first sewing machines were designed as early as the 1790s to increase efficiency in commercial manufacture. After several unsuccessful early attempts, the first lock stitch machine is attributed to Elias Howe, who improved on the various previous inventions and patented his machine in 1845. After failing to attract interest in his native America, he travelled to England in an attempt to create a market abroad. On his return to America he found that, in his absence, the sewing machine had been fully embraced, with several manufacturers infringing on his patent and making a decent profit. A court case followed, with many different creators involved, including the famed Isaac Merritt Singer, but Howe won the case and was awarded royalties from all guilty parties.

Whilst there were many companies copying and reproducing designs, Singer machines were the first to be commercially successful, due to Singer's adept marketing skills and the introduction of an affordable hire-purchase scheme. The sewing machine was in mass production from the 1850s and became a regular feature of the household for the creation of clothing and household furnishings. In terms of patchwork and quilting, it did not replace every method; styles that required piecing over papers, or the skill and decoration of hand quilting, continued. However, the machine was readily used for seamed patchwork, for joining large pieces of cloth, and for finishing the edges of quilts and coverlets, which would have taken a long time to sew by hand.

At the same time as the sewing machine was revolutionising home crafts, the interior of the Victorian home was becoming over-furnished and crowded. This style – with its excesses of furniture, ornaments and textiles – gradually filtered down through the social classes. Brightly coloured, expensive velvets, silks and satins were used to show off wealth and status, and patchwork was no longer limited to bedcovers but could create almost any furniture cover or decorative ornament throughout the home. Many smaller pieces were intended to be table covers and throws to be shown off in the Victorian parlour,

Opposite: Baby blocks coverlet, made from velvets and silks with a crazy patchwork border and bobble fringe, c. 1890s, 198 x 221cm. Made by Catherine Issell Briggs (née Jarvis), dressmaker and co-owner with her husband in Chelsea of an upholstery business.

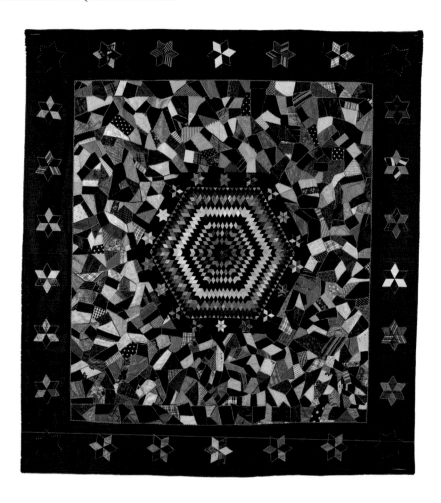

Crazy patchwork coverlet, c. 1870s, 213 x 200cm, made by Frances Fletcher (née Cope), with a mosaic diamond centre and a border of red silk. The rich velvet and silk fabrics and the patchwork styles typify the later Victorian period.

and items such as tea cosies, decorative pin cushions and chair cushions were popular projects that were printed in women's domestic magazines and specialist publications such as *Weldon's Practical Patchwork*. Hand-pieced mosaic patchwork, log cabin and crazy patchwork embellished with applied motifs and decorative embroidery were all in vogue. For fashionable women, there was now no question of using cotton for any patchwork projects. Mrs Pullan, in her *Lady's Manual of Fancy Work* in 1859, stated:

> Of patchwork with calico, I have nothing to say. Valueless indeed must be the time of that person who can find no better use for it than to make ugly counterpanes or quilts from pieces of cotton. Emphatically is the proverb true of cotton patchwork … It is not worth either candle or gas light.

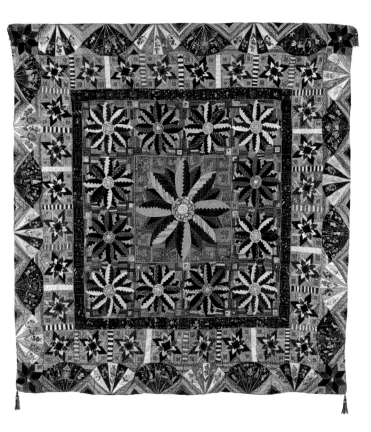

Jubilee coverlet, 1887, 204 x 202cm. An elaborate silk and velvet pieced and embroidered quilt, made to commemorate Queen Victoria's Golden Jubilee. Made by Mrs Mills of Crook, it was given as payment to her landlord in lieu of rent.

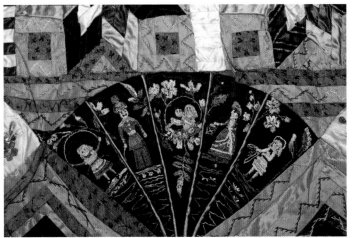

Detail of the embroidered figures on the outer fans of the Jubilee coverlet. It is likely these were embroidery transfers, commercially available.

This scathing assessment of the use of cotton fabric was partly due to its increasing accessibility to the mass market. By contrast, the invention of aniline dyes made silks and velvets even more desirable due to their new vibrant and attractive colours, which could not be replicated on cotton and linen. The first synthetic aniline dye, Mauveine or Perkin's Mauve, was created in 1856 when chemistry student William Henry Perkin conducted a failed experiment with coal tar in an attempt to produce the anti-malaria drug, quinine. When washing out the beakers, he created a bright purple solution, and from then on a whole array of colours followed closely behind, including fuchsine in 1859 (later renamed 'magenta' after the battle of that same year), safranine (a purple/red colour like the saffron crocus) and indulines (which were a range of blues, taking their name from indigo). The popularity of mauveine increased even more when Queen Victoria wore a silk mauveine-dyed dress to the Royal exhibition in 1862.

Crazy patchwork tea cosy, c. 1900, 36 x 23cm, with decorative embroidered embellishment over the seams and within each patch.

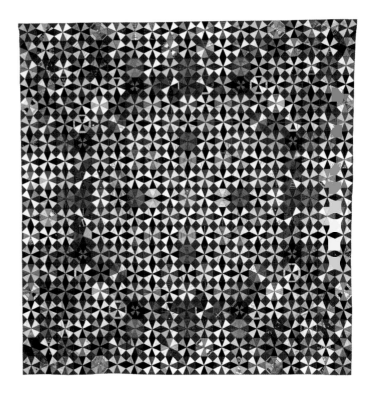

Kaleidoscope quilt, c. 1890–1900, 216 x 220cm. Silk mosaic patchwork made by Elizabeth Watson, a farmer's daughter from Cumbria. This brightly coloured piece was made for her bottom drawer, but she never married, leaving the quilt unused.

By the end of the century, continual experiments and developments had created a vast range of synthetically produced colours, although with varying degrees of success. Not all attempts were stable or colourfast; this, together with the practice of 'weighting', means that patchwork made from synthetically dyed silks and velvets rarely survives in good condition. 'Weighting' was the term given to the practice of adding large quantities of metallic salts when preparing the silk filaments, to increase the weight of the silks and therefore increase the manufacturer's profits. Although this gave the impression of a heavier, better quality silk and caused the fashionable 'rustling' effect popular in the voluminous skirts of the day, it made the fabric very brittle. Consequently, silks from the late Victorian period often shatter irreparably.

By the late nineteenth century manufacturers no longer produced the skilfully designed and intricately patterned cotton prints that were characteristic of quilts and coverlets in the early nineteenth century. Instead, small repeating patterns such as floral motifs were popular and used in day dresses and blouses, available in slight variations and a limited number of colours. Novelty prints, known as 'conversation prints', were all the rage, and often featured animals, sporting motifs or everyday household objects, some of which were both humorous and peculiar. One conversation-print patchwork top in the Guild's collection contains a wealth of different designs, including dogs and cats, umbrellas, padlocks, horseshoes, razors, trapeze artists, dominoes, cards and farm tools such as rakes, spades and forks. More unusual designs include a rat crouched upon an egg and a monkey sitting on a playing card waving a flag. Ironically, this patchwork top has an outer border of fabric with illustrations drawn by Walter Crane, a designer and illustrator involved in the Arts and Crafts Movement of the late nineteenth century.

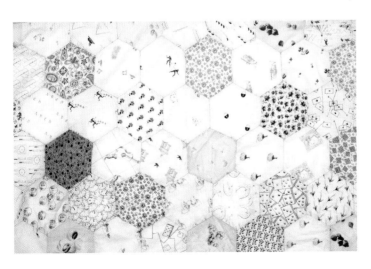

Hexagons made from conversation-print cottons, featuring a range of unusual designs including animals, household and garden objects.

37

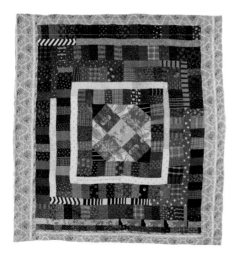

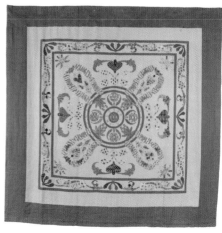

Frame quilt, c. 1890, 222 x 235cm, featuring Art Nouveau-inspired floral designs in the centre, a style which followed on from the Arts and Crafts movement, which favoured excellence in design and hand-crafted skill over cheap mass production.

Appliqué coverlet, 1875–99, 256 x 211cm, made by the Ladies Work Society, a charity that offered suitable and respectable employment for distressed gentlewomen by using their needlework skills. The original label is still intact on the reverse.

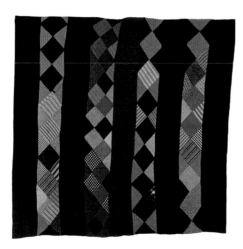

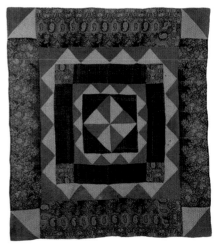

Purple strippy quilt from the second half of the nineteenth century, 240 x 228cm. Made from vibrant synthetically dyed plain purple wool strips and diamond patchworked strips of wool and cotton in plain, striped and check designs.

Welsh patchwork quilt with a pinwheel design, c. 1880s, 193 x 210cm, made from a variety of wool fabrics including a shawl design. The wadding is an old blanket, and the quilting motifs include the Welsh spiral.

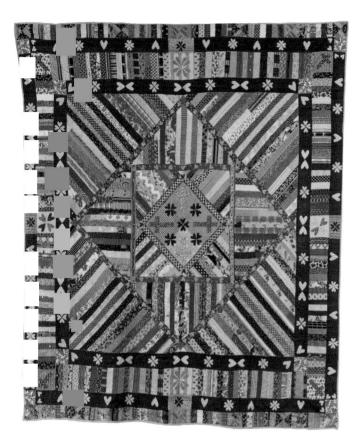

Hearts and crosses
coverlet, late
nineteenth century,
187 x 24cm, made
from strips of
dress and
furnishing cottons
with borders of
vibrant Turkey Red
fabric with
appliquéd hearts
and crosses.

It seems at odds with the philosophy of a movement that championed handcrafted goods and quality of workmanship that his design should be used in conjunction with cheap, mass-manufactured and often poorly printed conversation-print fabrics.

Turkey Red cotton was a popular fabric used in patchwork and wholecloth quilts throughout the second half of the nineteenth century. A bright and colourfast fabric, it was often teamed with plain white cotton to produce simple and striking designs ranging from strippy quilts and coverlets to more complex blocks such as the basket motif, or was incorporated with other plain and printed cottons in mosaic or log cabin designs. The name refers to the complex dye process using the madder root to produce a vibrant red colour. It originated in India, spread through Asia Minor, and was produced in Smyrna and Adrianople, giving rise to the British term 'Turkey Red'. It travelled to France with Greek dyers in 1747, and to Scotland in 1785, where the first successful Turkey Red dye works in Britain

was established in Dalmarnock, on the Clyde. The process was very complex and could involve several weeks of cleansing, oiling, dyeing, fixing and washing. The first items made from Turkey Red were kerchiefs or bandanas in the early nineteenth century, followed by its use in fashionable day dress up to the 1840s. By the late nineteenth century it had become more popular for underwear, children's clothing and bathing costumes.

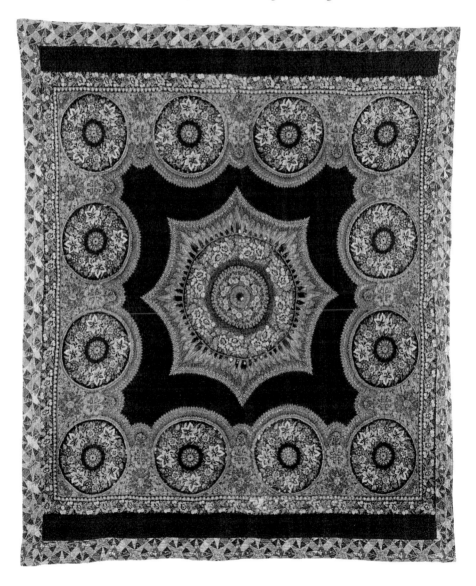

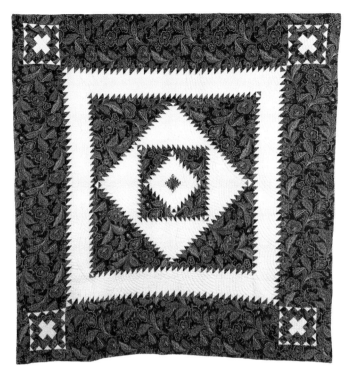

Turkey Red discharge-printed sawtooth medallion quilt, c. 1900, 195 x 210cm, with paisley and floral designs. It was made in Maryport, Cumbria, and has a traditional all-over circular wave quilting design.

The durable qualities of Turkey Red fabric made it ideal for use in items that were regularly laundered, such as quilts, household textiles and clothing such as petticoats. At first only the yarn could be dyed and then woven into cloth. Gradually, techniques developed to allow the dyeing of the cotton cloth once it was already made, producing both plain cloth and patterned designs through a discharge printing technique. The design would be bleached out of a plain Turkey Red cloth and the other colours then added in, often including the full range of black, blue, yellow and green. Popular designs included floral and geometric shapes and what became known as the Paisley design, originally an Indian motif that became synonymous with the Scottish town in which it was printed. Turkey Red fabric was also exported all over the world, with plain weave Turkey Red fabric being produced for export, and twill weave dominating the home market. As a popular fabric, it was sold in large quantities and was available in different grades depending on the maker's purpose and purse. Whilst smaller scraps may have been used in mosaic patchwork and log cabin quilts that contain Turkey Red fabric, large pieces of the fabric would have been purchased especially for quiltmaking. Turkey Red remained in popular use until the early twentieth century, when an artificial alternative provided a cheaper option that was quicker to manufacture.

Opposite: The circular Turkey Red discharge-printed motifs on this quilt (c. 1850–90, 196 x 221cm) have been pieced from four large squares originally intended to make shawls, giving a continuous border of circles and a central medallion.

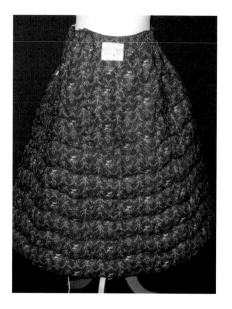

The end of the nineteenth century also saw the arrival of signature quilts and coverlets. These were often created in a church or community environment for the purpose of raising money. Each participant would pay to have their name or initials on a patch of fabric, which could be their own signature or written by a selected person. This would then be embroidered, usually in contrasting thread to the background colour, and the patches pieced together to form a full coverlet or quilt, which could be raffled to raise further funds. A central inscription and sometimes an embroidered image are used to describe the purpose of the event. These interesting quilts are useful in documenting local communities, and investigation into the names that appear on these quilts often indicates important or influential families of the period (such as mayors, philanthropists

Turkey Red quilted petticoat, commercially made by quilted clothing specialists Booth and Fox, London. The quilted channels start from the hips to prevent bulk around the waist.

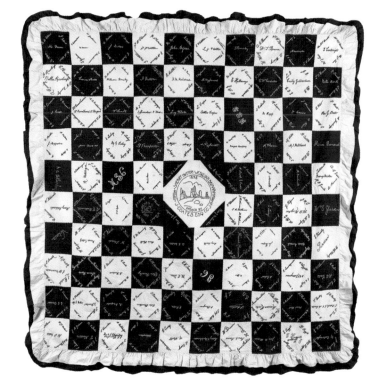

Plain Turkey Red twill and white cotton signature coverlet, made for Sheriff Hutton Wesleyan Bazaar, 1898, 222 x 222cm. The central embroidery depicts Sheriff Hutton Castle and each square has up to five signatures, often in family groups.

and local business owners) and family surnames that have a local connection to the place in which the quilt was made.

It is important to note that, whilst the majority of makers are presumed to have been women, male patchwork- and quilt-makers are not unheard of. Whilst sewing skills were considered a female accomplishment, the contribution of men in making quilts and patchwork – and assisting with complex geometry and template drafting for projects – should be recognised.

The story of one famous quiltmaker from the nineteenth century is that of Joseph Hedley, known as 'Joe the Quilter'. Trained as a tailor, Joe also made his living through quiltmaking in the village of Warden in Northumberland. He was well known for the high quality of his workmanship and his quilts were densely packed with floral and lattice diamond designs. However, the knowledge of his life and work is probably so well recorded due to the grim manner of his death: he was the victim of a horrific and unsolved murder in 1826, which captured the imagination of the public and the press. A printed broadsheet described how Joe was brutally stabbed sixteen times and dragged out to the coal shed of his humble cottage at the age of 76, murdered for the rumour that, despite his modest living and receipt of parish relief, he had money hoarded away. A surviving example thought to have been made by Joe is in Beamish Museum.

Tyneside signature quilt, 1897, 222 x 222cm, with signatures surrounding an embroidered outline of Queen Victoria's head. Made by the Primitive Methodist Connexion in Jarrow on Tyne to celebrate the Diamond Jubilee.

Tailoring and staymaking were predominantly male professions and small businesses including drapers and haberdashers would have been run by men or husband-and-wife teams. In many cases, the maker owning or being related to a family drapery business is cited as part of the historical provenance of a quilt's history upon donation, with the implication that this is where the varied scraps of fabrics for the piece were obtained. Tailor William Singleton is the maker of two exquisitely pieced items in the Guild collection: a cotton star patchwork coverlet with braid edging, each piece surrounded by crazy patchwork, and a circular fitted table cover made from grey, blue and red wools in a geometric design, also edged with braid decoration. Both pieces were made c. 1860–80. Nicholas Lambert, a tailor from Ryde on the Isle of Wight, made a suit wools quilt consisting of rectangular tailors' samples backed with a purple printed cotton with a stripe

design. Herman Korf, a tailor who lived in Ongar, made a double-sided star and rectangular pieced wool coverlet with scalloped edging between 1880 and 1900. It was believed that the wool and suit fabrics in the coverlet were available to him through his profession.

Another feature of the nineteenth century was the creation of military quilts, often referred to as soldiers' or uniform quilts. These are often made from small pieces of colourful wool in elaborate and precisely pieced geometric designs. It was romantically presumed that convalescing soldiers made them whilst recovering from their war wounds in a hospital bed, and that the fabrics had been taken from the uniforms scavenged on the battlefield. Whilst this may be true in some cases, many different military personnel were responsible for the creation of these quilts, and soldiers as well as army tailors made these military pieces with leftover scraps of fabric from making or altering uniforms. They were often very heavy due to the weight of the wool fabrics used, and the bright colours show the linings as well as the outer colours of uniforms in the nineteenth-century armed forces.

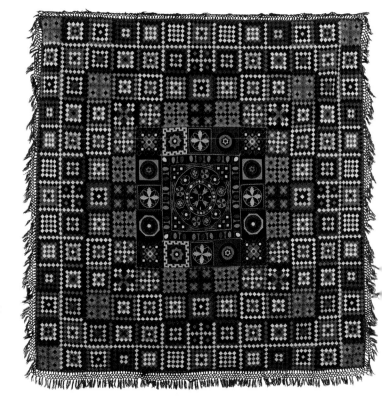

Uniform coverlet, 1860–80, 209 x 211cm, made from squares of military uniform wool arranged in blocks surrounding a central circular medallion. The coverlet is backed with tartan fabric and has a blue wool fringe around the edge.

FLUCTUATING FORTUNES: 1900–50

THE TWENTIETH CENTURY was a time of decline and revival for patchwork and quilting. From their position as popular and practical activities at the start of the century, the crafts endured several phases of hardship as they struggled through the impact of two world wars, competed with commercially manufactured alternatives, and tried to find relevance in a changing society.

The late nineteenth century and the first decades of the twentieth century were prolific times for the production of wholecloth quilts. Wholecloth quilts are made from large pieces of the same fabric, joined together to form the quilt top. The three quilt layers – the top, centre wadding and backing layer – are held together with different combinations of quilted motifs. Variations of wholecloths include some pieced designs, such as strippy (large strips of often alternate colours with corresponding rows of quilting patterns) and Sanderson Star quilts, but the piecing is generally larger and the concentration is on the textured design produced by the quilting stitches rather than a complicated patchwork pattern.

In Wales, itinerant quilters continued to travel between households, lodging with families and producing quilts required that year. As well as the professional, there were also village quilters, and those who established quilt clubs. In the Scottish borders, Hawick became known for its two-day quilt sales during the 1920s, which raised funds for local churches. Regional variations of wholecloth quilts developed during the mid-nineteenth century. Before this time, motifs and layouts were individual to the maker and incorporated naturalistic forms

Turkey Red and White cotton Sanderson Star Quilt, early twentieth century, 209 x 225cm, hand pieced and hand quilted with North Country twisted cable, rose and square diamond motifs.

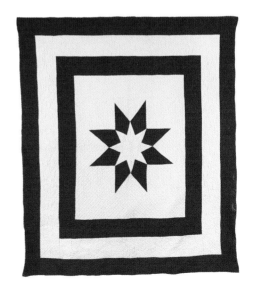

North Country wholecloth quilt, c. 1900–20, 208 x 242cm with a floral printed border. The design includes a feathered bordered medallion, square diamond infill and a border of fan motifs.

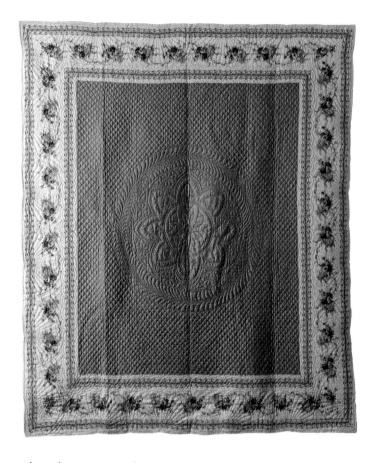

with no distinctive template or set pattern. By the end of the century, specific regional styles and motifs to identify a quilt to its geographical region of origin. In the North Country, feathers, roses and twisted cable motifs were popular in layouts featuring a central medallion of motifs, surrounded by a plainer infill motif and an overall quilt border. The Welsh layout was more structured, defined by set frames that contained popular motifs such as leaves, spirals and Welsh pears. The Hawick style was distinguishable by the use of Hawick hearts, thistles, and daisies (known as 'Gowans'), and a clamshell rather than square diamond infill. Whilst these motifs are useful for identification, people did travel and sometimes took their favourite motifs with them; there are always some exceptions to the rule.

The emergence of the professional 'quilt stamper' in the North of England was very influential on the style and layout of wholecloth quilts.

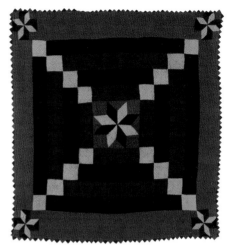

White cotton North Country wholecloth quilt, c. 1900–20, 214 x 231cm, with a pink cotton reverse. The quilting motifs include roses, feathers, shells and leaves. The blue pencil is still clearly visible.

Welsh frame quilt, early twentieth century, 198 x 204cm, made from wool with prairie point edging. The traditional Welsh framed quilting layout features spirals, leaves and a scissors motif.

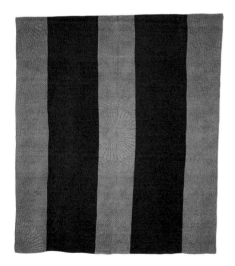

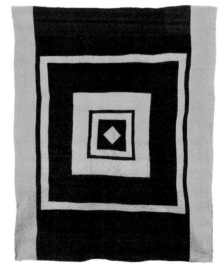

Blue and gold wool Welsh strippy, early twentieth century, 195 x 213cm, with a framed layout; the hand quilted design is stitched in red thread. Motifs include the fan, wheel and church window with spirals inside.

Red and yellow Welsh quilt c. 1900–25, 182 x 219cm, with a framed design on one side and a strippy design on the other. It has a blanket as wadding and is simply quilted.

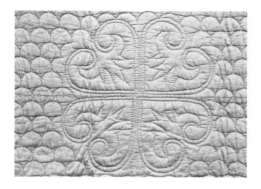

The central heart motif from a blue Hawick wholecloth quilt, c. 1920–30, 193 x 213cm made by Janet Pow. The Hawick Heart also features along the edges and the clamshell infill was popular in the Scottish Borders.

Their creation of a free-flowing design and layout moved away from the previous delineated frame layout, and this style came to characterise Welsh designs. Stampers were professional quilt markers who would draw quilt designs on tops sent in by customers, or sell ready-made marked tops they had prepared in advance. The term 'stamper' originates from the iconic blue pencil, which bore a similarity to the ready printed blue embroidery designs available in this period. These professional markers were highly skilled, and often used favourite and trademark designs. Women at home would try to emulate their design expertise, but they would rarely achieve the same standard and quality. The start of this service is attributed to George Gardiner, a draper of Allendale in Northumberland. It became so popular that he soon employed many apprentices, one of whom was Elizabeth Sanderson, the creator of the striking 'Sanderson Star' design, who became more famous than her employer. In Wales, professional quilters would travel to different households, making quilts to order. The customer would normally provide all materials, food and lodgings for the quilters, who would then board with them for the duration of the quilt-making.

Quilts could also be produced in a more local environment, and quilt clubs were often formed in small communities as a respectable way for women to supplement the family income, especially if the husband was ill or injured and therefore unable to work. Members would each pay a weekly subscription, and lots would be drawn to decide the order in which the quilts would be made. The quilters worked long hours to produce one quilt per week or fortnight until every club member had received their order. The necessary speed of the work meant that the design and motifs were sometimes limited, but the quilts themselves were frequently made to a high standard.

At the start of the twentieth century, patchwork styles were a continuation of those that were fashionable in the last decades of the Victorian period. The Victorian preference for adorning every possible surface with embellished patchwork remained popular, and the usual crazy patchwork and mosaic designs were still being created in the first years of the twentieth century. Whilst Victorian fancywork continued to find favour in middle-class or aspiring lower-class households, quilts, coverlets and tops made from cottons and practical wool fabrics were still being produced. These could be equally decorative and utilitarian in design and function. Women would use the materials they had to hand, and several examples in

the Guild's collection use striped and checked shirting cottons to produce decorative and surprisingly contemporary-looking patchwork pieces.

Many traditional crafts, including quiltmaking, declined during the inter-war years. The First World War had resulted in changes to the social, domestic and working roles of women. Combined with changes in fashionable home interiors and increasing competition from commercially manufactured alternatives, patchwork and quilting skills were not being passed on through the generations as in previous decades. To counteract this loss of skill, the Rural Industries Bureau (RIB) established a scheme in 1928 to revive traditional rural crafts, using existing quilters and providing classes for the next generation. Concentrated in the poorer areas of Wales and the North, it provided a means of income otherwise unavailable to struggling families. Goods made under the scheme were sold to high-class London-

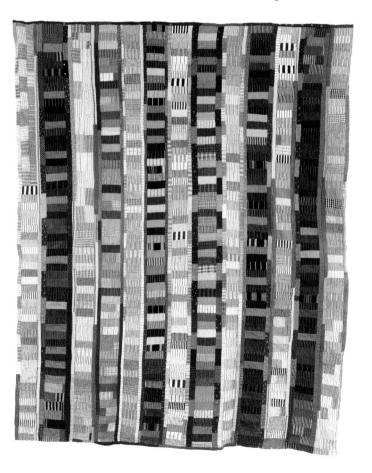

Cotton strippy top, c. 1900–10, 154 x 188cm, made in the Channel Islands. The 'ladders' effect has been achieved through horizontal and vertical strips of shirt cottons, and shows how simple, practical fabrics can create a striking design.

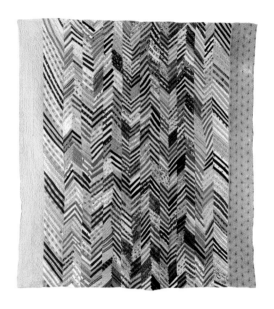

and Cardiff-based clients who bought 'Durham' or 'Welsh' quilted items containing traditional motifs.

Many prestigious clients ordered items through the RIB scheme, including hotels such as Claridges, The Dorchester and Grosvenor House. Two quilts ordered for the refurbished Art Deco wing of the Claridges Hotel in Mayfair in the 1930s, are in The Quilters' Guild collection. Other institutions also played a significant role. The Northern Industries Workrooms (NIW), inspired by the RIB, provided similar employment, producing high-quality quilted goods made from desirable silk and satin fabrics. Unlike the home-based RIB scheme, the NIW set up two workshops

Chevron strippy quilt, c. 1900, 220 × 234cm. A variety of printed and plain cottons placed in chevron strips make a contemporary-looking design that is very effective.

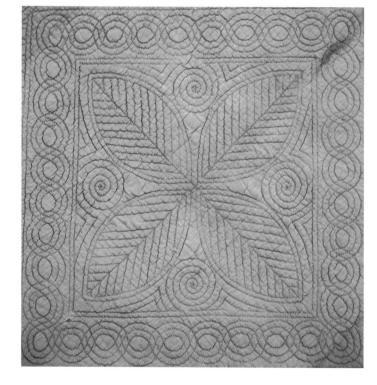

Central leaves motif from a peach-coloured wholecloth quilt, 196 × 226cm, commissioned for the new Art Deco wing of Claridges hotel in the 1930s through the Rural Industries Bureau.

based in Barnard Castle and Langley Moor where women were taught and worked on their orders. These orders included not just quilts, but also household objects and clothing such as dressing gowns, tea cosies and lingerie cases. The Women's Institute also encouraged patchwork and quilting as part of their educational remit, and the Quakers started a centre in the Rhondda Valley offering education and leisure programmes to the hard-hit mining communities of South Wales. The progress made by all of these schemes was important, but any momentum gained in reviving quilting was abruptly halted by the arrival of the Second World War, when the programmes were abandoned. They had still made a major impact in Wales, however, due to the number of quilters being involved in such small rural areas; although the orders ceased, demand for adult education classes continued.

The Second World War had a dramatic impact on civilian society in Britain, lasting well beyond the actual duration of the war. Clothing rationing was introduced in 1941 and was not lifted until 1949, causing a strain on available resources for patchwork and quilting. Women were encouraged to 'make do and mend', recycling and reusing worn-out clothes and bedding for everyday practical purposes within the home. Whilst this idea of using scraps for making patchwork covers and patched clothing was not a new concept, there was little to be creative with and anything that was created was severely restricted by the resources available.

Wartime shortages were greatly aided by overseas institutions, which made and sent over

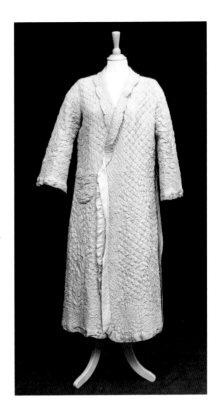

Above: Blue and pink dressing gown made under the Northern Industries Workrooms scheme in Barnard Castle during the 1930s. These items were made to order and were popular, along with other domestic items such as tea cosies and cushions.

Right: Shadow quilted slippers and bag made in 1939 by Mabel Lawson as a wedding gift. Shadow quilting, in which coloured wool shows through the semi-transparent top fabric to make the design, was popular in the 1930s.

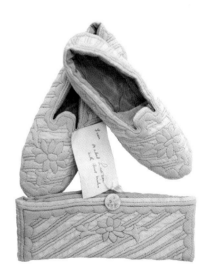

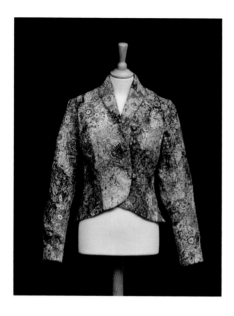

quilts for distribution to bombed-out families, the armed forces and hospitals. The Canadian Red Cross had made a significant contribution during the First World War, supplying quilts, clothing and bandages, and answered the call again from 1939, making thousands of quilts from any scraps of fabric and clothing they had to hand. Out of necessity the quilts were quickly made and simple in design, often featuring crazy patchwork or simple blocks which could be made by different women and collectively pieced together at group meetings. Many quilts were simply tied together with wool at intervals to speed up completion. The central wadding could vary depending on the resources available, and it was not unusual for old clothing or worn quilts to fill the centre if nothing else was available. The individual makers of the quilts were anonymous, but printed or woven Red Cross labels were attached to every quilt and sometimes included the name or region of the branch where it was made. Whilst these labels are helpful in identifying Canadian Red Cross quilts, many of them were unpicked and removed

Crazy patchwork embroidered jacket, made by Winifred Childs in 1948. A very creative product of two eras – made to a 'New Look' vogue pattern but using fabric scraps and a recycled lining in times of post-war shortage.

Canadian Red Cross quilt, c. 1939–45, 185 x 152cm, made from a range of cottons and rayon blouse fabrics to support the British war effort. Although the individual makers remain unknown, the branch 'Hallville, Ont'[ario] is embroidered on the front.

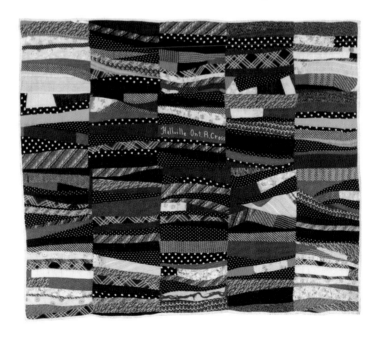

because of the tainted association of accepting charity. The Imperial Order of the Daughters of the Empire was another charity that made a significant contribution to the war relief in Britain. Originally founded in 1900 to provide patriotic support for Canadians fighting for the British Empire in the Boer War, they sent across quilts and other goods, including a gift of eighty-seven wedding outfits to be loaned to British servicewomen in 1944.

Throughout the first half of the twentieth century, society and fashions were changing, and traditional homemade quilts faced increasing competition from commercially produced alternatives. Women sought the latest affordable fashions in modern domestic soft furnishings such as eiderdowns, Marcella quilts, 'Comfy' quilts and candlewick bedspreads, which were advertised in magazines. Traditional patchwork and quilts were associated with the old-fashioned styles of previous generations. The impact of two world wars had changed the social and working role of women, who now had more opportunities for work outside the home. Traditional quiltmaking was time consuming, and many women lacked the leisure time and sewing skills of their mothers' and grandmothers' generations. One such competitor was the 'Comfy' quilt, produced by the British Quilting Company, which operated from 1912 to 1970 in Waterfoot, Rossendale. The Comfy label advertised the convenience of the quilt as 'Washable and Hygienic', and it had a simple reversible design, often consisting of just two fabrics – one plain and one floral or paisley patterned – in a frame layout or a central diamond and border. The machine quilting always used a zigzag design. As well as quilts, the company produced a range of products including mattress protectors, cot quilts and coverlets, nightdress sachets, slippers, dressing gowns and tea cosies.

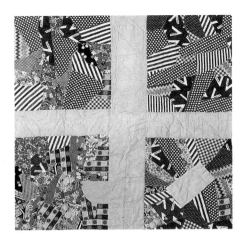

Top: Detail of four crazy patchwork blocks from a Canadian Red Cross quilt, c. 1940s, 164 x 203cm. They contain a novelty wartime fabric, featuring a 'V' (for Victory) with morse code dots and dash.

Bottom: 'Comfy' quilt, c. 1920–39, 200 x 246cm, commercially manufactured and machine quilted in a characteristic zigzag pattern. Affordable and fashionable manufactured quilts competed with hand-made quilts, which required skill and time, and were seen as increasingly old-fashioned.

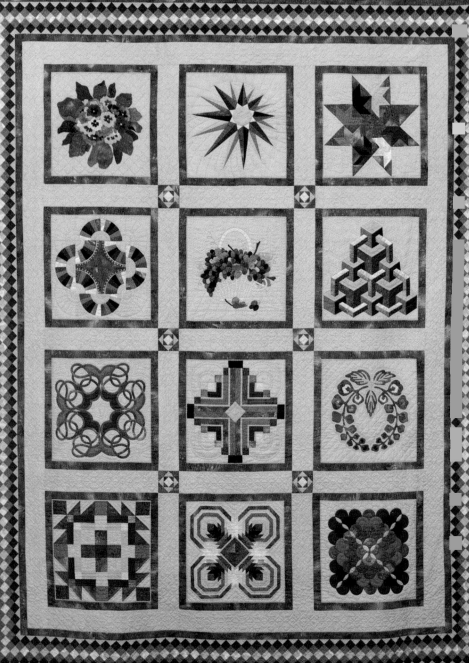

THE REVIVAL: 1950–2000

B Y THE END of the Second World War, patchwork and quilting was a dying craft. A new society wanted to move away from the old-fashioned style associated with 'making do' that characterised the wartime era. However, a few notable individuals were keeping the craft alive. Their knowledge and enthusiasm was passed on through community education classes to increasing numbers of interested women, as the popularity of quilting once again began to grow, creating a sociable leisure activity, an interesting and creative hobby and an emerging form of recognised art.

An important champion for the continuation of North Country wholecloth traditions was Amy Emms (1904–98). She was taught traditional North Country quilting by her mother, who helped her thread needles by the age of seven and got her quilting by the age of fourteen. She began her prolific career teaching other members of the British Legion, which she joined during the war. Her natural flair as a teacher and designer, as well as her exquisite craftsmanship, led to a legendary reputation, and the quilting classes she taught were always in very high demand. She gained her City and Guilds Diploma in 1952 under the guidance of Mrs Lough and taught at the Sunderland Community centre and Weardale WI, giving demonstrations at quilt shows and museums across the country. In 1957, she completed her finest achievement: Her daughter's quilted wedding dress, making her a proud mother and a media sensation. Her renowned status and reputation led to many commissions and she was never without a project. Her love of quilting and teaching spread the once dying craft of North Country quilting to a wide and appreciative audience, and in 1983 she was awarded an MBE for her outstanding contribution to quilting.

Wholecloth quilting in Wales was encouraged and practised by several key figures, including Jessie Edwards and Irene Morgan. Jessie Edwards was one of the leading quilt teachers in South Wales who taught under the Rural Industries Bureau scheme, and continued to teach until 1959. She made a lot of quilts to order, and one of these is held in The Quilters' Guild collection. Irene Morgan learnt to quilt under the Rural Industries Bureau

Opposite:
'Rebecca's Sampler', 2000, 198 x 246cm, made by Rebecca Collins, commissioned by Region 13 of The Quilters' Guild. It uses blocks of different patchwork and appliqué designs, including a star, a mariner's compass, flying swallows, a fan, and log cabin blocks.

in the 1920s under the guidance of Mrs Lace, in Trecynon, Aberdare. Her skills are recorded by Mavis Fitzrandolph in *Traditional Quilting*, where her skilful use of traditional patterns was recognised. She also ran classes, first in Aberdare and then in Porthcawl and Bridgend, and won many prizes for her quilting.

Averil Colby (1900–83), practitioner, writer and historian, also played an important role in the craft's revival. She was producing, researching and writing about patchwork and quilting at a time when the craft and its heritage was largely unexplored and quiltmaking was generally unfashionable. Averil started patchwork when she joined the Women's Institute in Liss in 1932, going on to make many pieces including some prestigious commissions, such as a hexagon patchwork pochette for Queen Mary in 1935 and the hexagon patchwork lining to a workbox presented to Princess Elizabeth in 1938. Her style of patchwork using mosaic pieced hexagons from floral prints was widely emulated throughout the 1960s and 1970s. Her role as a researcher and historian was also integral to the development of patchwork and quilting in the twentieth century. Publishing her first book at the age of 58, she authored five books, four on patchwork and quilting; *Patchwork* (1958), *Patchwork Quilts* (1965), *Quilting* (1971) and *Pincushions* (1975). A previously unexplored and disregarded topic, her work became the foundation that inspired subsequent generations of quilt researchers and historians, another important aspect of her quilting and patchwork legacy.

Above left: Lilac satin acetate quilt made by Amy Emms, 1993, 220 x 262cm. It was commissioned by The Quilters' Guild heritage committee for the collection.

Left: Amy Emms with her daughter Olive on her wedding day, 1957, wearing the quilted wedding dress made by her mother. Amy called this her proudest achievement, and this dress was a press sensation.

Alongside the impact of teachers and practitioners, the invention of new synthetic fabrics such as rayon, nylon and polyester in the twentieth century meant that different fabrics became available for use in patchwork and quilting. Rayon, a semi-synthetic artificial silk, was created from naturally occurring cellulose fibres and was produced by the British company Courtaulds from 1905. Nylon, made from synthetic polymers, was first produced in 1935 and was intended as a substitute for silk. It was used in place of silk during shortages in the Second World War, for many military uses including parachutes. Polyester, a non-biodegradable synthetic fibre, was first marketed as Terylene in 1941, before adopting several other names and growing in popularity through the 1950s and 1960s, becoming known as the fabric that didn't need ironing. Combining polyester with natural fibres (as in polycotton, for example) was a good way to reduce the unnatural feel of the fabric whilst retaining some of the advantages of resistance and durability given by the artificial fibre. Unfortunately, many of these silky synthetic fibres were not suited to patchwork and quilting due to their soft and fluid nature, leading to very misshapen pieces over time.

Printed designs became increasingly abstract as the century progressed; the discovery of Tutankhamun's tomb in 1924 inspired an Egyptian style throughout the 1920s, and the development of commercial screen printing between the wars allowed an artistic freedom of design to flourish. The scientific advancements that characterised the 1950s

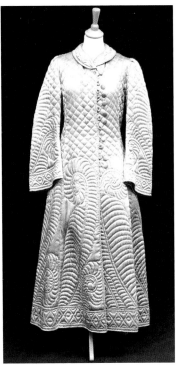

Gold satin dressing gown made by Welsh quilter Irene Morgan, c. 1950s.

Hexagon patchwork samples by Averil Colby, writer, historian and practitioner, who was well known for her mosaic patchwork technique. Her work influenced the style of patchwork produced in the 1960s and 1970s and her research left an important legacy to quilt historians.

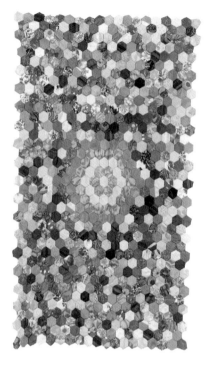

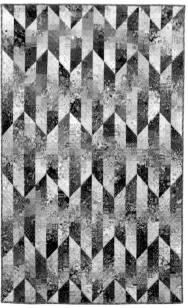

were echoed in fabric designs, which were based on linear and molecular drawings of a new scientific age. The bright floral patterns popular in the 1960s and 1970s also found their way into patchwork.

By the 1970s, patchwork and quilting along with other traditional crafts had grown in popularity. Crafts became a leisure pursuit rather than being viewed as a practical necessity, and patchwork and quilting became more visible as they increasingly formed a part of popular culture. Exhibitions of quilts were held at the American Museum in Bath and a major exhibition from the Whitney Museum of American Art, *Abstract Design in American Quilts*, travelled to London in 1975. The BBC even produced a series, *Discovering Patchwork*, in 1978. Classes continued, groups formed, and eventually, it was felt that a national organisation was required to represent the craft. The Quilters' Guild was founded in 1979 with the intention of encouraging not only the continuance of the craft, but also its development and the education of future generations.

At the start of the twenty-first century, patchwork and quilting is popular all over the world, as a creative and social hobby as well as a medium for the professional textile artist. Quilters may use traditional techniques, but also experiment with new ideas, materials and inspirations, allowing the craft to develop and progress. Contemporary quilters create textile art, now intended to be seen on a wall rather than on a bed. They are inspired by world events, politics and the environment, and use patchwork and quilting as a way to express their views and reflect the world around them.

Above: Mosaic patchwork cot coverlet, c. 1960s, 64 x 111cm, made from cotton, polycottons and artificial fabrics in vibrant colours. Patchwork was not widely practised at this time, and pieces from this era often followed Averil Colby's mosaic patchwork style.

Left: 'Colourwash' strippy quilt by Deirdre Amsden, 1987, 145 x 217cm. The colourwash technique was pioneered by the maker, and uses the tones of different floral printed cottons (including Liberty Tana Lawn print) to create the effect of gradation of colour.

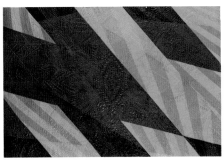

'Dry Dock I (Pink Boat)' by Jo Budd, 1988, 292 x 189cm. Pictorial contemporary quilt inspired by a boat in dry dock awaiting painting. This quilt was purchased with assistance from the Art Fund and V&A/MLA Purchase Grant.

'Field Force' by Michele Walker, 1996, 300 x 200cm, made from household plastic bags with polyester wadding. It has a 'tyre tread' quilting pattern that represents tyres destroying the natural landscape of the South Downs.

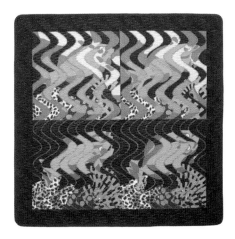

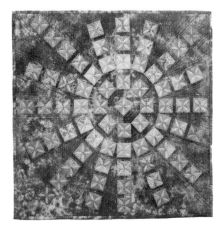

'Fish Dance I' by Pauline Burbidge, 1992, 60 x 59cm. Made in the style of a large quilt 'intercut fish harmony' in Glasgow Museum Collection, which began as paper collage studies which were then repeated in fabric.

'Touchstones' by Sara Impey, 1998, 61 x 61cm, from The Quilters' Guild Nineties Collection. The pattern, colour and texture were intended to suggest a fragment of ancient flooring.

CONCLUSION

THE STORY OF PATCHWORK and quilting over the last three centuries is one that follows the changes and developments of the society and economy in which it was performed. Each quilt tells its own story and can be appreciated for the important glimpse it provides into the private domestic sphere of the past. The importance and relevance of quilts as social history is evident in the way they are collected and interpreted in museum exhibitions, with a major recognition in the form of the exhibition at the Victoria and Albert Museum, 'Quilts 1700–2010'. The main challenge for the twenty-first century remains the competition from cheaply manufactured alternatives in times of economic hardship, and a decline in sewing skills as a natural result of the different emphasis in education. Crafts are now hobbies, which cost more money than their manufactured equivalent, rather than necessary and practical household skills. They also require the precious commodity of time in a fast-moving and busy world. However, with a renewed interest and popular recognition of the importance of keeping traditional crafts alive, it is hoped that patchwork and quilting will continue to be practised, to evolve, to remain relevant to contemporary society, and to provide enjoyment and beauty for future generations.

FURTHER READING

Allan, Rosemary. *Quilts and Coverlets: The Beamish Collections.* Beamish Open Air Museum, 2007.

Arthur, Liz. *Seeing Red: Scotland's Exotic Textile Heritage.* Collins Gallery, 2007.

Bower, Helen. *Textiles at Temple Newsam.* Leeds Museums and Galleries, 2000.

Bradfield, Nancy. *Costume in Detail: Women's Dress 1730–1930.* Eric Dobby Publishing, 1995.

Colby, Averil. *Patchwork.* Batsford, 1958.

Colby, Averil. *Patchwork Quilts.* Batsford, 1965.

Colby, Averil. *Quilts.* Batsford, 1972.

Crill, Rosemary. *Chintz: Indian Textiles for the West.* V&A Publishing, 2008.

Emms, Amy. *Amy Emms' Story of Durham Quilting.* Search Press, 1990.

FitzRandolph, Mavis. *Traditional Quilting.* Batsford, 1954.

Garfield, Simon. *Mauve: How one man invented a colour that changed the world.* Faber and Faber, 2000.

Hake, Elizabeth. *English Quilting Old and New.* Batsford, 1937.

Hart, Avril and North, Susan. *Seventeenth and Eighteenth-Century Fashion in Detail.* V&A Publishing, 2009.

Head, Carol. *Old Sewing Machines.* Shire Publications Ltd, 1982.

Hefford, Wendy. *The Victoria and Albert Museum's Textile Collection: Design for Printed Textiles in England from 1750 to 1850.* V&A Publishing, 1992.

Inlaid Patchwork in Europe from 1500 to the present. Staatliche Museum, Berlin, 2009.

Jenkins, Mary and Claridge, Clare. *Making Welsh Quilts.* David and Charles, 2005.

Jones, Jen. *Welsh Quilts.* Towy Publishing, 1997.

Long, Bridget. *The Quilters' Guild Collection: Contemporary Quilts Heritage Inspiration.* David and Charles, 2005.

Long, Bridget. *Elegant Geometry: American and British Mosaic Patchwork.* Catalogue from the Exhibition at the International Quilt Study Centre, Nebraska, 2011.

March, Maxine, Mansi, Anna and Maxwell, Jackie. *Sewing in Wartime: Canadian WWII Red Cross Quilts.* Quilt Museum and Gallery, 2010, exhibition catalogue.

Montgomery, Ann and Sheehan, Declan (editors). *Fabrics and Fabrication.* The Ulster Folk and Transport Museum, 2001.

Osler, Dorothy. *Traditional British Quilts.* Batsford, 1987.

Osler, Dorothy. *North Country Quilts: Legend and Living Tradition.* Bowes Museum, 2000.

Parry, Linda. *A Practical Guide to Patchwork from the Victoria and Albert Museum.* Unwin, 1987.

Parry, Linda. *Victoria and Albert Museum's Textile Collection: British Textiles from 1850 to 1900.* V&A Publishing, 1997.

Prichard, Sue. *Quilts 1700–2010.* V&A Publishing, 2010.

Quilt Studies Issues 1–12. Journals of the British Quilt Study Group

Rae, Janet. *The Quilts of the British Isles.* Constable, 1987.

Rae, Janet *et al. Quilt Treasures: The Quilters' Guild Heritage Search.* McDonald Books, 1995. (Re-published 2010 by The Quilters' Guild)

Rae, Janet and Travis, Dinah. *Making Connections: Around the World with Log Cabin.* RT Publishing, 2004.

Rothenstein, Natalie (editor). *Barbara Johnson's Album of Fashion and Fabrics.* V&A Publishing, 1987.

Sheppard, Josie. *Through the Needle's Eye: The Patchwork and Quilt Collection at York Castle Museum.* York Museums Trust, 2005.

Stevens, Christine. *Quilts.* Welsh Folk Museum, 1993.

Sykas, Philip. *The Secret Life of Textiles: Six Pattern Book Archives in North West England.* Bolton Museums, 2005.

Sykas, Philip. *Identifying Printed Textiles in Dress 1740–1890.* From www.dressandtextilespecialists.org.uk/Print%20Booklet.pdf.

Tozer, Jane and Levitt, Sarah. *Fabric of Society: A Century of People and Their Clothes 1770–1870.* Laura Ashley Ltd, 1983.

PLACES TO VISIT

The Quilt Museum and Gallery, St Anthony's Hall, Peasholme Green, York YO1 7PW. Telephone: 01904 613242. Website: www.quiltmuseum.org.uk

The Quilters' Guild collection consists of approximately eight hundred patchwork, quilted or appliqué objects, demonstrating a wide range of styles and techniques. The collection started with the formation in 1979 of The Quilters' Guild, a membership organisation and educational charity created to promote the allied crafts of patchwork, quilting and appliqué. The collection steadily increased through donations and purchases to evolve into today's specialist collection. It is currently housed and displayed in a changing programme of textile exhibitions at The Quilt Museum and Gallery in York, Britain's first museum dedicated to quiltmaking and textile arts.

The collection has several examples of patchwork and quilting from the eighteenth century, the oldest patchwork in the collection being the 1718 silk patchwork coverlet. The oldest quilt is a cot quilt made from linen, thought to date from the first decade of the eighteenth century. Collection items from the nineteenth century are fairly comprehensive, starting with some stunning examples of early cotton pieced mosaic and frame coverlets. Dating from the late nineteenth and early twentieth centuries, the wealth of traditional wholecloth quilts from Wales, the North Country and the Scottish borders show the heyday of their production.

Due to the rise and fall in popularity of patchwork and quilting in the twentieth century, the collection is naturally more sporadic for this period. Quilts made under national schemes to revive quilting as a traditional craft are featured, as well as small domestic items, which were popular to make at home. Key champions for the continuation of traditional quilting such as Amy Emms and Jessie Edwards are represented, as well as patchwork practitioner, teacher and author Averil Colby. A steady increase in the popularity of patchwork and quilting in recent years is reflected by the collection items dating from the 1970s and after.

MUSEUMS WITH QUILT COLLECTIONS (UK)

The American Museum in Britain, Claverton Manor, Bath BA2 7BD. Telephone: 01225 460503. Website: www.americanmuseum.org

Beamish Museum, Beamish, County Durham DH9 0RG. Telephone: 0191 370 4000. Website: www.beamish.org.uk

Beck Isle Museum, Pickering, North Yorkshire YO18 8DU. Telephone: 01751 473653. Website: www.beckislemuseum.org.uk

The Bowes Museum, Barnard Castle, County Durham DL12 8NP. Telephone: 01833 690606. Website: www.bowesmuseum.org.uk

Forge Mill Needle Museum, Needle Mill Lane, Riverside, Redditch B98 8HY. Telephone: 01527 62509. Website: www.forgemill.org.uk

Glasgow Museums, 220 High Street, Glasgow G4 0QW. Telephone: 0141 287 4833.
 Website: www.glasgowlife.org.uk
Jen Jones Quilt Centre, Lampeter Town Hall, High Street, Lampeter, Ceredigion
 SA48 7BB. Telephone: 01570 422088. Website: www.welshquilts.com
The Manor, Hemingford Grey (home to the Patchworks of Lucy Boston, by
 appointment only), Huntingdon, Cambridgeshire PE28 9BN.
 Telephone: 01480 463134. Website: www.greenknowe.co.uk
Museum of London, 150 London Wall, London EC2Y 5HN.
 Telephone: 020 7001 9844. Website: www.museumoflondon.org.uk
National Museums Scotland, Chambers Street, Edinburgh EH1 1JF.
 Telephone: 0300 123 6789. Website: www.nms.ac.uk
The National Wool Museum, Dre-Fach Felindre, Llandysul, Carmarthenshire SA44
 5UP. Telephone: 029 2057 3070. Website: www.museumwales.ac.uk/en/wool
Ryedale Folk Museum, Hutton-le-Hole, North Yorkshire YO62 6UA.
 Telephone: 01751 417367. Website: www.ryedalefolkmuseum.co.uk
Shipley Art Gallery, Prince Consort Road, Gateshead NE8 4JB. Telephone: 0191 477
 1495. Website: www.twmuseums.org.uk/shipley-art-gallery
St Fagans: National History Museum, Cardiff CF5 6XB. Telephone: 029 2039 7951.
 Website: www.museumwales.ac.uk/en/stfagans
Ulster Folk and Transport Museum, Cultra, Holywood, Northern Ireland BT18 0EU.
 Telephone: 028 9042 8428. Website: www.nmni.com/uftm
The University of Leeds International Textile Archive (ULITA), St. Wilfred's Chapel,
 Maurice Keyworth Building, University of Leeds, Leeds LS2 9JT.
 Telephone: 0113 343 3704. Website: ulita.leeds.ac.uk
The V&A Museum, South Kensington, Cromwell Road, London SW7 2RL.
 Telephone: 020 7942 2000. Website: www.vam.ac.uk
York Museums Trust, St Mary's Lodge, Marygate, York YO30 7DR.
 Telephone: 01904 687687. Website: www.ymt.org.uk
*It is important to note that many museums have quilts as part of their social history or
textiles collections, and so there are many more which are not listed here.*

MUSEUMS WITH QUILT COLLECTIONS (INTERNATIONAL)

American Folk Art Museum, 2 Lincoln Square, Columbus Avenue at 66th Street,
 New York, NY 10023. Website: folkartmuseum.org
American Textile History Museum, 491 Dutton Street, Lowell, Massachusetts, MA
 Telephone: 01854-4221. Website: www.athm.org
International Quilt Study Center & Museum, 3 N. 33rd St., University of Nebraska,
 Lincoln, NE 68583. Website: www.quiltstudy.org
La Conner Quilt and Textile Museum, 703 Second Street, PO Box 1270, La Conner,
 WA 98257. Website: www.laconnerquilts.com
Museum of the American Quilter's Society, The National Quilt Museum, 215 Jefferson
 Street. P.O. Box 1540, Paducah, KY 42002. Website: ww.quiltmuseum.org
New England Quilt Museum, 18 Shattuck Street, Lowell, Massachusetts, MA 01852.
 Website: nequiltmuseum.org
Old Sturbridge Village, 1 Old Sturbridge Village Road, Sturbridge, Massachusetts,
 MA 01566. Website: www.osv.org
Shelburne Museum, 6000 Shelburne Road, PO Box 10, Shelburne, VT 05482.
 Website: shelburnemuseum.org
Textile Museum, 2320 S Street, NW, Washington, DC 20008-4088.
 Website: textilemuseum.org

INDEX